One of the legendary classics among German photography books, August Sander's *Face of Our Time*, is now available again. Compiled by August Sander (1876-1964) himself, the book was first published by the Kurt Wolff Verlag in 1929, with a foreword by German writer Alfred Döblin (1878-1957). On its first publication, it was advertised as follows:

"The sixty shots of twentieth-century Germans which the author includes in his *Face of Our Time* represent only a small selection drawn from August Sander's major work, which he began in 1910 and which he has spent twenty years producing and adding fresh nuances to. The work as a whole is divided into seven groups, corresponding to the existing social structure, and is to be published in some 45 portfolios of 12 photographs each. The author has not approached this immense self-imposed task—the like of which has never been attempted before on this scale—from an academic standpoint, nor with scientific aids, and has received advice neither from racial theorists nor from social researchers. He has approached his task as a photographer from his own immediate observations of human nature and human appearances, of the human environment, and with an infallible instinct for what is genuine and essential. And he has brought the task to completion with the fanaticism of a seeker after truth, and without prejudice either for or against any one party, tendency, class, or society."

144 pages, 60 duotone plates

August Sander

Face of Our Time

Sixty Portraits
of Twentieth-Century Germans

Introduced by Alfred Döblin

Schirmer Art Books

Translated from the German by Michael Robertson

Schirmer Art Books is an imprint of
Schirmer/Mosel Verlag GmbH, Munich
For trade information please contact:
Schirmer Art Books, John Rule, 40 Voltaire Rd., London SW4 6DH, England
or Schirmer/Mosel Verlag P.O. Box 221641, 80506 München, Germany
Fax +49/89/338695

Lithos: O.R.T. Kirchner GmbH, Berlin
Typesetting: Gerber Satz, Munich
Printing and binding: Gorenjski Tisk, Kranj

ISBN 978-3-88814-292-5

A Schirmer/Mosel Production
www.schirmer-mosel.com

Contents

Alfred Döblin

Faces, Images, and Their Truth

I Are Individuals True, or What is True?

During the Middle Ages, there was a notorious controversy among scholars. It was a thousand years ago. The disputants were called the Nominalists and the Realists. Of course, the same controversy is still continuing today, although under a different name. It is difficult to say today in a single sentence what it was all about a thousand years ago, because in the meantime the meaning of words has changed a great deal, but I shall do my best here to suggest what the state of play was: The Nominalists took the view that only individual objects are genuinely real and existent. The Realists, by contrast, held that only generalities, universals — a biological genus, for example, or an idea, were actually real and existent. What has all this to do with faces and images? It will become clear shortly; for the moment, we shall discuss two kinds of levelling process: the levelling of human faces by death, and levelling by society and its class structure. What do I mean by levelling? Assimilation, the blurring of personal and private distinctions, the fading away of these differences under the stamp of a greater power — and so there are two powers here, that of death and that of human society.

II The Levelling of Faces and Images by Death

Some time ago, a young woman was pulled out of the Seine. The unknown woman, who had probably committed suicide, was taken to the Paris mortuary. She soon began to attract attention there. And I will tell you why. A death-mask was taken from this 'unknown woman from the Seine' *(l'inconnue de la Seine)*. Many people now have reproductions or casts of it.

What was it that was so remarkable about the unknown young woman, and what makes so many people look at the photographs or casts of her death-

mask? I shall try to describe the head from a photograph. It is the face of a young woman or a girl, perhaps 20–22 years old. She has a plain hairstyle, the hair falling smoothly to the right and left of the parting. One cannot see her eyes, her eyes cannot see, for the girl is dead, and the last thing her eyes saw was the bank of the Seine, the waters of the Seine, and then her eyes closed, and then the short, cold shock came, and the dizziness, with suffocation and numbness quickly descending. But it did not stop there. I should like to think that the girl did not go into the Seine gladly. What followed her initial despair and the brief horror of suffocation can now be seen from the picture, in her face, and this is why she was not simply cast aside like hundreds of others at the mortuary.

The unknown woman's mouth is slightly drawn in, her lips are almost pursed, and then the cheeks follow, and there arises, below the peacefully closed eyes — closed against the cold water, closed also in order to see only an inward image — there arises, below these eyes, around this mouth, a truly sweet smile; not a smile of rapture or delight, but a smile of approaching delight, a smile of expectation, a smile that is calling or whispering and has caught a glimpse of something intimately known. The unknown woman is approaching something that offers happiness. And, in the face's appearance and the way the photograph reproduces it, there is an uncanny element of seduction and temptation. While there is a certain soothing quality in any thoughts of death, this face radiates something almost bewitchingly tempting.

What sort of interpretation is this? Let us return to what I mentioned above, the levelling of the human face by death. There are books showing collections of death-masks. I have one in front of me. And when one leafs through it — the lovely unknown woman is among them — it becomes clear that they are all rather uniform. The faces are certainly different; Wieland's face could certainly not be mistaken for those of Frederick the Great or Jonathan Swift, for Oliver Cromwell's moustached, strong-willed face, or for Lorenzo Medici's broad, ample face. Some of the faces seem to be bursting with health, while others are emaciated by long illnesses. But what they all have in common is something negative: something has been taken away from each of these persons. They have not simply closed their eyes, and this gives them an appearance of not being alive, or perhaps of just being asleep. The immense

burden of momentary existence, of change and alteration, has been erased from these faces. Death has carried out a massive retouching operation.

And what remains after the great retouching, after the erasure? The human face *en bloc*, the product of a lifetime's work and the working of life on flesh and bone, on the contours of the facial features, on the shape of the forehead, nose and lips. The remnants of faces portrayed in the death-masks, their expressions, are stones that have been rolled around and polished by the action of the sea for decades, and it is no longer a single, momentary movement that is being recorded and preserved. What lies before one is the *en bloc* product. Work has now finished. What called a halt, levelled all these faces out and made them uniform, is one and the same death. They became individual, personal, and unique in life through two great processes: they were shaped by their race and the development of their personal talents — and by the external elements of nature and society, which alternately promoted and hindered their development. But now there is nothing that either promotes or hinders them any longer; it is right for their eyes to be closed, since there is nothing more that can radiate from these persons. And, in the presence of these dead faces, one feels that they are not only silent and enclosed within themselves, but that they are also diminished, that they have become objects in alien hands. They *were* at one time active, and that was what formed their faces. Now they undergo something, they are passive, a cast is taken from them. Death as something positive. For a time, this was Hugo Wolf, Dante, Fox, Frederick the Great — now they are all vanquished, assuaged, they are silent objects.

The block of life, I would say, remains. But the lovely unknown woman from the Seine is smiling? Yes, there is an effect of some sort that emanates from this new, nameless power. Only a few allow themselves to be borne away from here easily. Many fall asleep, at best; or rather, at best a gentle sleep comes over them when they enter the anonymous realm of Death. But some do approach a kind of happiness. Individual life has only hurled them hither and thither, has only impeded them. Now the obstacles are taken away from them. Now that their eyes are shut to this individual existence they can welcome with a smile another, different stage of existence, unknown to us; they can purse their lips, full of sweet expectation, full of longing.

III The Levelling of Faces and Images by Society

Now there is another folder in front of me, one with images of living people who have not yet fallen into the great washtub in which their personalities and all their activities are scrubbed away from them. The water that polishes these stones can still be seen on them. They are still rolling in the sea that pitches us all about. And while what overwhelmingly confronts us in the death-masks is one and the same, unaltering anonymity — we are looking into a vast, peculiar moonscape — here we are looking at: individuals? Strange. You would think you were looking at individuals. But suddenly — one finds that even here one is not actually looking at individuals. Admittedly it is not the vast, monotonous moonscape of death whose light is falling on all these faces; it is something else. What? We are now talking about the astonishing levelling out of faces and images by human society, by class distinctions, by the cultural attainments of each class. This is the second kind of standardizing or assimilating anonymity. To use a term from the medieval controversy mentioned at the beginning: we have effectively seen that death is a universal, one that has proved to be a real power and force; but this does not yet indicate what death really is, whether it is the Great Reaper or a sweet bringer of peace. And now, in the portraits of the living, we are confronted with a second universal, one that proves to be equally real, effective and powerful: we are confronted with the collective power of human society, of class distinctions, of the different cultural attainments of each class.

IV Details from this Group

Each of us knows a number of people, and we recognize them when we meet by specific, entirely personal characteristics that they have. All the people we encounter are only individuals, and each person has a name, as well as specific, unrepeatable, and characteristic tokens of identification. We need not mention fingerprints, which are actually, as forensic scientists are aware, only one of various facts about a specific person that enable that person to be identified. As I say, a forensic fingerprint is not necessary. In everyday life, other qualities are sufficient, things that may not be as accurate and numerically

exact, but which are nevertheless exact enough. A man has such and such a height, posture, and face — an immense complex of information that we can nevertheless take in at a single glance; there is a characteristic voice, walk, gesture, and even a brief selection of these features is more than enough for us to be absolutely certain of identifying the man. And to identify means to recognize him as a unique being. His uniqueness is quite obvious to us.

But what can we say about an ant-heap? There may be some five hundred ants moving across a path, coming from a root, or from a pile of stones, in a fast and quite conspicuous movement. A hundred yards away there is an even larger crowd of them at work. No matter how closely we observe the insects, it is impossible for us to perceive more detail than certain general characteristics of the species, or insignificant differences between individuals. It is absolutely impossible to differentiate between them. And yet there is no doubt, or at least I should imagine so, that here, as with bees, all of the insects recognize each other and can distinguish themselves one from another.

What I am trying to say here is something that is widely known, although it is seldom applied to human beings — the fact that, viewed from a certain distance, distinctions vanish; viewed from a certain distance, individuals cease to exist, and only universals persist. The distinction between the individual and the collective (or the universal), then — with the wisdom of a Solomon — becomes a matter of varying degrees of distance. As we are human beings, we only concern ourselves with individuals — with humans. With coloured people we already find it more difficult. If we were elephants, we would divide humans, I mean at the zoo, into those who just walk past and those who give us sugar; the keepers would form their own group, a particular species of human. Looking at human beings, i.e. at ourselves, in this way, has enormous advantages. It is not necessary to take the elephant's point of view, the distance conferred by a scientific viewpoint or a historical viewpoint, or a philosophical or economic one, would be sufficient. We suddenly become strangers to ourselves and learn something about ourselves. It is immensely worthwhile to learn something about oneself. Whether one can make use of it is another question, but the knowledge itself is valuable. In the pictures we have before us, it is a matter of expanding our field of vision, as I shall go on to show. There is much to be learnt from it.

V There are Three Types of Photographer

I do not regard the photographic lens as seeing any differently from the human eye. It may be that it sees more poorly since it is not movable, but what the lens offers us is the same as what we see ourselves. Unlike the retina of the human eye, the plate behind the lens can record images, and photographers use these images in various ways, making them serve different purposes. That is purely a matter for the photographers, but photographers, like painters, can teach us to see specific things, or to see them in a specific way. First, there are photographers who see artistically, for whom the face only provides the subject-matter for a picture, photographers who are only looking for effects of an aesthetic type. The sort of pictures they produce are called 'very interesting', or 'very nice', or 'original'. These are values in their own right, of course, but there is nothing to be learnt from them, either about human beings, or for one's own sake.

There is another type of photographer that flourishes wherever one looks. Although there are so many of them, they mean more to us than these masters of art do. The second sort want to produce pictures that have as great a 'likeness' as possible to the people in front of them. The photograph should be as 'similar' as possible, meaning that the personal, private, and unique aspects of the person concerned should be recorded on the plate. Going back a little, we recall our introductory remarks: these photographers of similarity are the Nominalists, and have no knowledge of the great universals. We would be doing these gentlemen too much honour if we said that they had considered their position in the great controversy of the intellects and resolutely sided with the Nominalists. One element of realism is clearly and indisputably present among this group of photographers, namely the desire to make money.

And then comes the third group. I haven't counted the pages I have written so far, or how many sentences I have spoken, but we can now raise the flag at last — we are finally getting to the point, our photographs! By now you can probably guess what this third type of photographer represents, and it wasn't mentioned above for nothing. The third group of photographers — I seem to be talking about a whole group, although there are only a few of them, and in Germany the only one I have encountered is Sander — this

third group are the conscious followers of Realism. They consider that the great universals are effective and real, and when they take a photograph, lo and behold the pictures are not likenesses in which Mr X or Mrs Y can be recognized clearly and easily. What one does recognize and ought to recognize, I shall tell you in the next section.

VI What One Should Recognize Here

Somehow the description I am giving here is turning out like a gigantic balloon that only has a very small basket hanging from it. But I have really only got a little more still to say. The truth has been made ready, and now a philosopher follows. The photographs you are to see here are this philosopher's expressions; each one speaks for itself, and altogether, in the way in which they are arranged, they are more eloquent than anything I could say. What you have before you is a kind of cultural history, or rather sociology, of the last thirty years. With his vision, his mind, his faculty of observation, his knowledge, and last but not least his immense photographic talent, Sander has succeeded in writing sociology not by writing, but by producing photographs — photographs of faces and not mere costumes. Just as one can only achieve an understanding of nature or of the history of the physical organs by studying comparative anatomy, so this photographer has practised a kind of comparative photography and achieved a scientific viewpoint above and beyond that of the photographer of detail. We are free to interpret his photographs in any way we wish, and taken as a whole, they provide superb material for the cultural, class, and economic history of the last thirty years.

One of the types one sees is that of the country people, who are probably stable because the form of the peasant smallholding has long had a certain stability. This group has therefore neither dissolved or vanished, although its significance may be declining. Among them one sees complete families, and even without seeing their ploughs and fields one can see that the work they do is rough, hard, and monotonous. It is work that makes their faces tough and weather-beaten. One can see, too, how they change under new conditions, how their faces are softened by wealth and easier forms of activity.

We move on to the type seen in the small town, and then to the closely

related varieties of city craftsman, and compare them to the modern industrialists. And we move on to the photographs of today's city proletariat. The sequence provides a quick overview of economic development during recent decades. To grasp the nature of this continuing development, one should not omit the conclusion to it that is reached in the figures from the workers' council, the anarchists and revolutionaries.

People are shaped by what they eat, by the air and light in which they move, by the work they do or do not do, and also by the peculiar ideology of their class. One can learn more about these ideologies — perhaps more than could be learnt from long-winded reports or accusing comments — merely by glancing at the pictures in group 3, those of the wealthy middle class and their children. The tensions of our time become clear when we compare the photograph of the working students with that of the professor and his so peaceful family, nestling contentedly and still unsuspecting.

A rapid change in moral attitudes has taken place during recent decades, a progression of these attitudes. In group 4, we have the Lutheran clergyman, a magnificent photograph in which he is surrounded by his pupils, although they already have faces that no longer match the expression on the face of their teacher or his gown. The village schoolmaster is still walking about in the country with his long beard and spectacles, strict and sober, an idealist and a brooder. The member of the student duelling society wears his little cap, has scars across his face, and senses the splendour of his sash. The quiet wholesale merchant and his wife belong to this group; these are pictures from Gustav Freytag's novel *Debit and Credit*, not of modern tycoons. But advancing behind them, other, newer types can already be seen. Society is in the midst of a revolution, the cities have grown to gigantic proportions, and while occasional original figures remain, new types are already developing. This is how today's young merchant looks, this is today's grammar-school pupil — who would have thought it possible twenty years ago, the way the characteristics of age have mingled, the way youth is marching on. And this pupil from a girls' grammar school dressed up like one of today's young ladies is already the perfect young woman. The way in which the distinctions between youth and adulthood have dissolved becomes palpable — the way in which young people have come to be dominant, an urge for rejuvenation and renewal that even has biological effects.

Entire stories could be told about many of these photographs, they are asking for it, they are raw material for writers, material that is more stimulating and more productive than many a newspaper report.

These are my comments. Those who know how to look will learn more quickly than they could from lectures or theories; they will learn from these clear and powerful photographs, and will discover more about themselves and more about others …

Plates

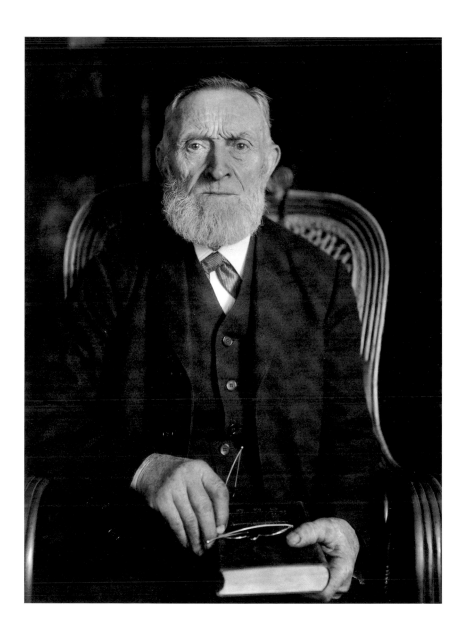

1 Farmer, Westerwald

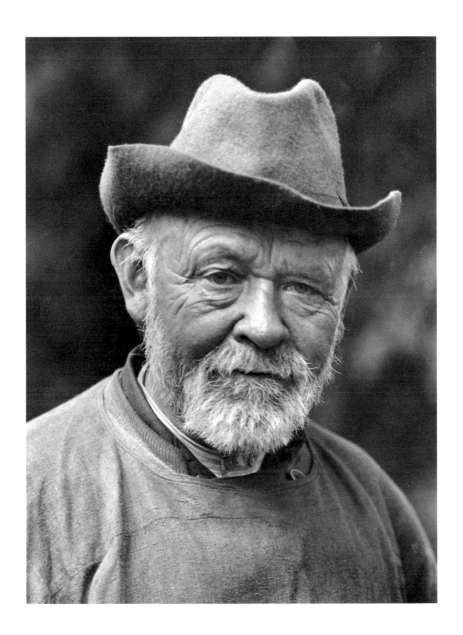

2 Shepherd 1913

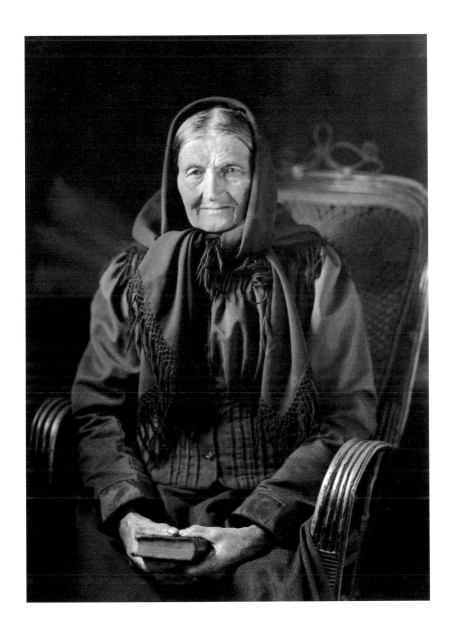

3 Westerwald farming woman 1913

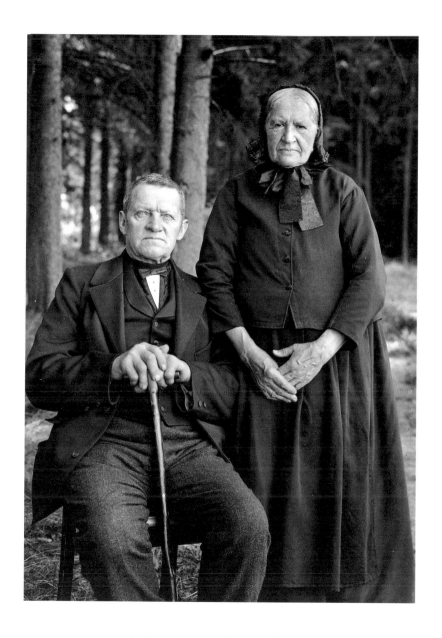

4 Farming couple, Westerwald 1912

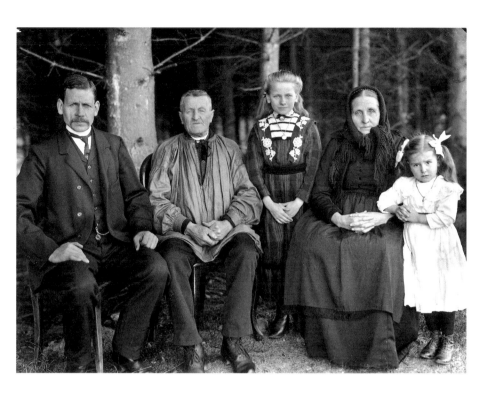

5 Three generations of a farming family 1912

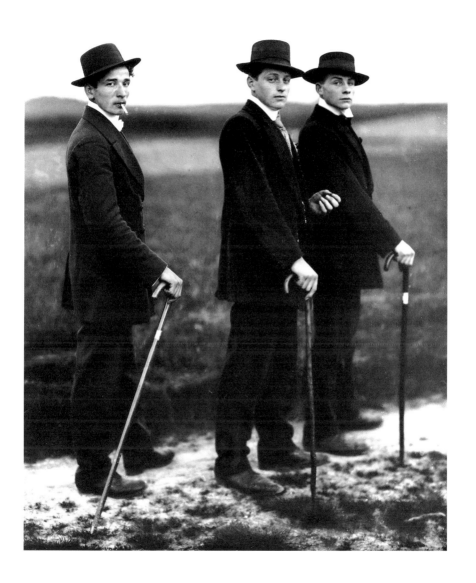

6 Young farmers

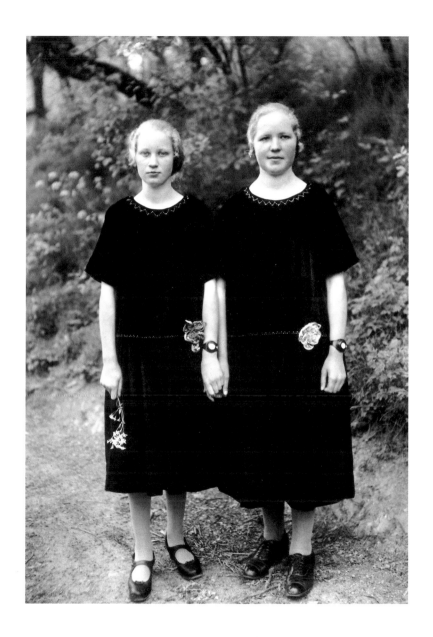

7 Country girls

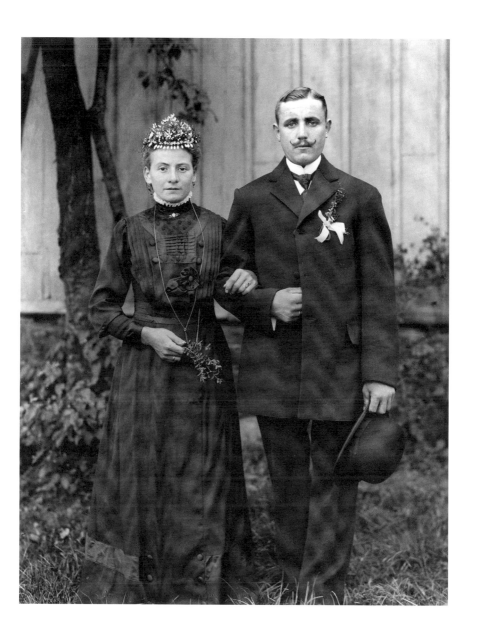

8　Country bride and groom　1914

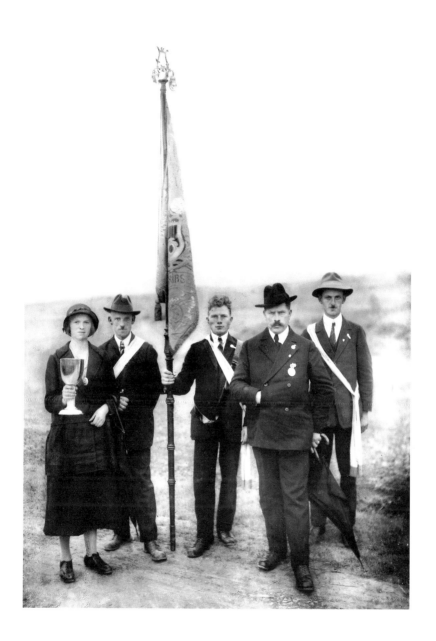

9 Prizewinners 1927

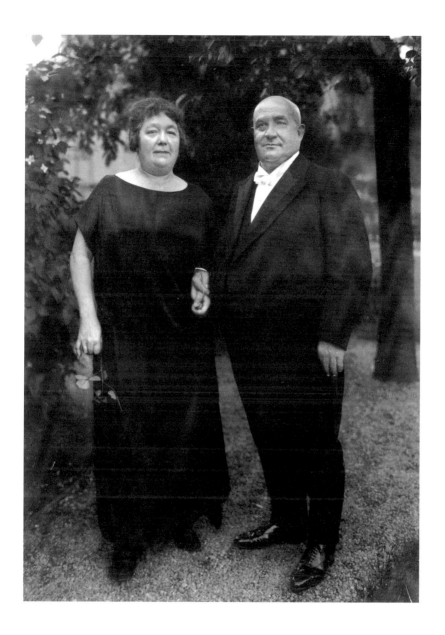

10 The landowner

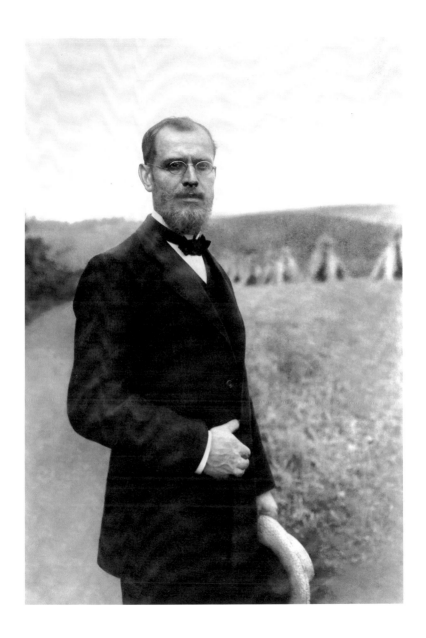

11 The teacher 1910

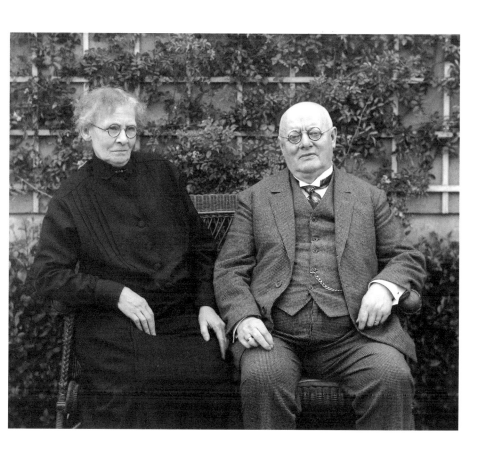

12 Small-town citizens of Monschau, near Aachen

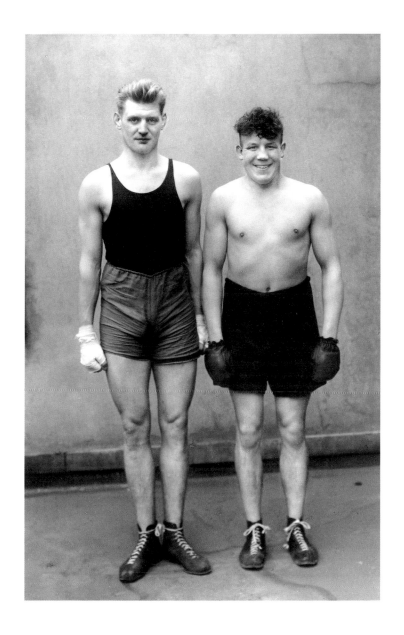

13　Boxers

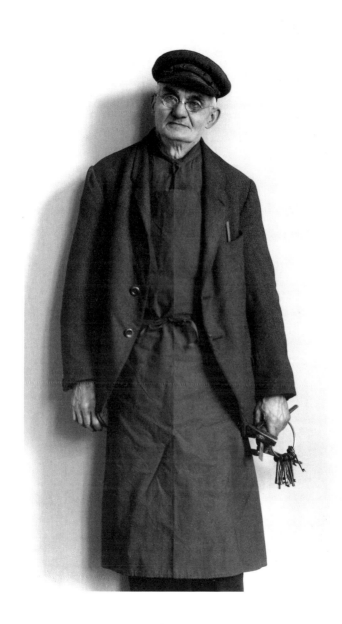

14 Locksmith

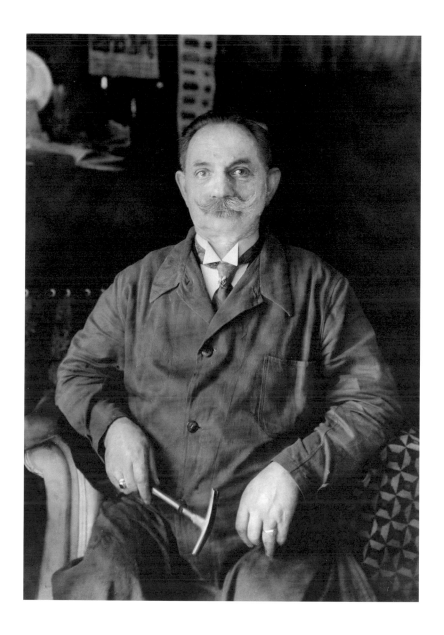

15 Interior decorator, Berlin 1929

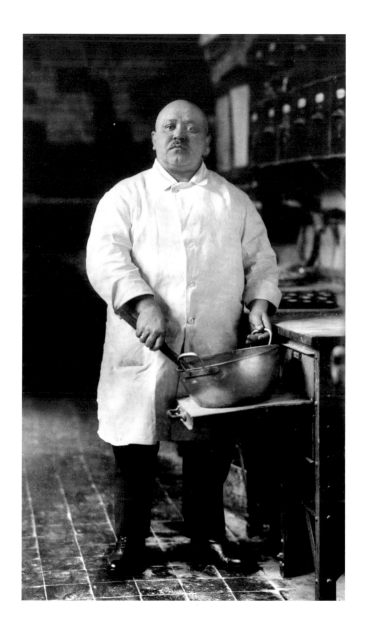

16 Pastrycook

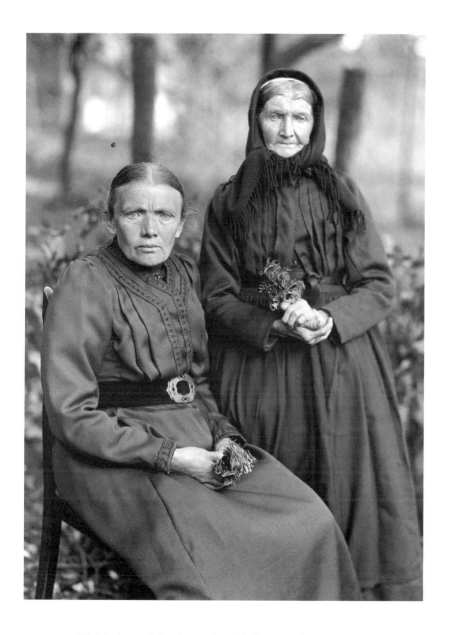

17 Mother and daughter, wives of a farmer and a miner 1912

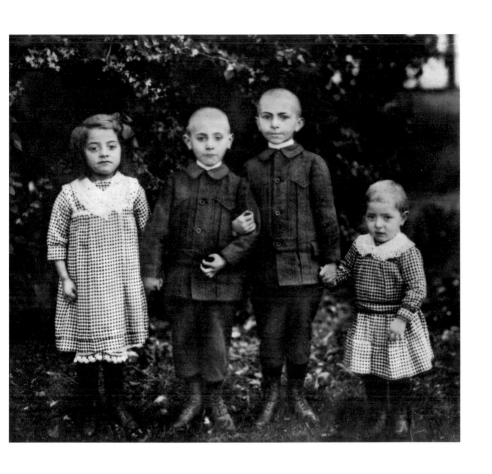

18 Proletarian children in the country

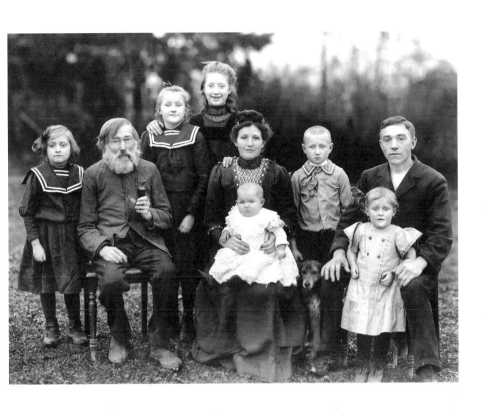

19 Worker's family

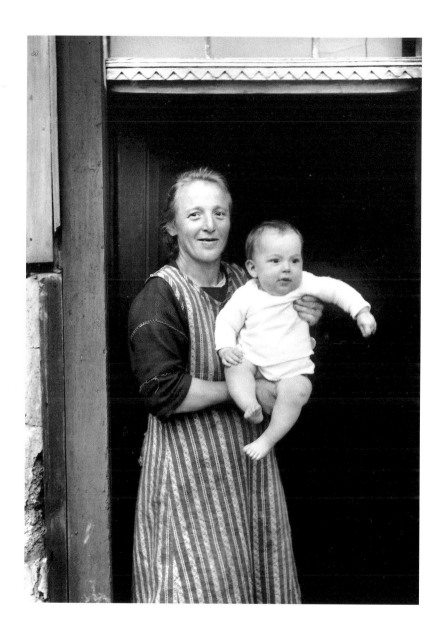

20 Proletarian mother

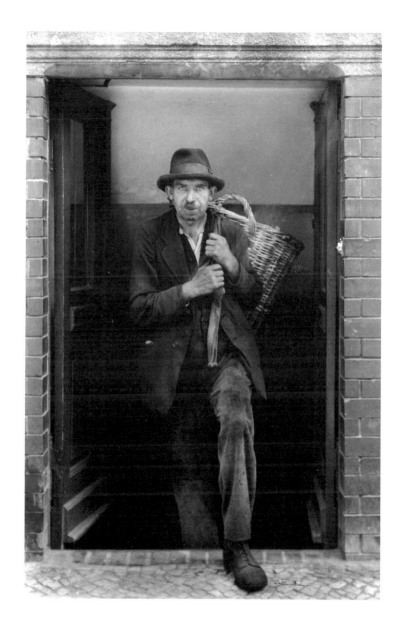

21 Coalman, Berlin 1929

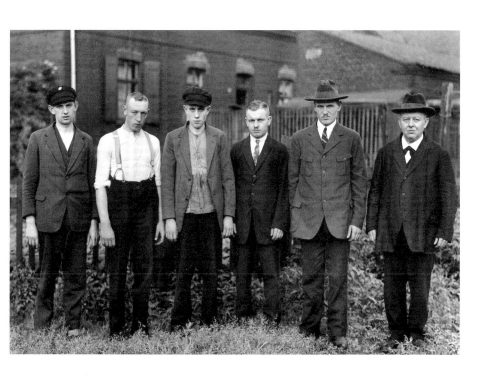

22 Workers' council in the Ruhr 1929

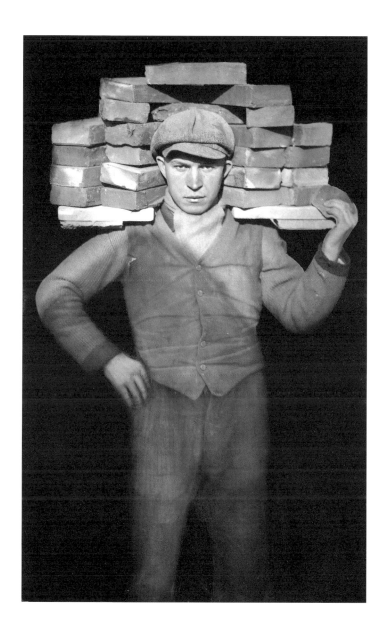

23 Odd-job man

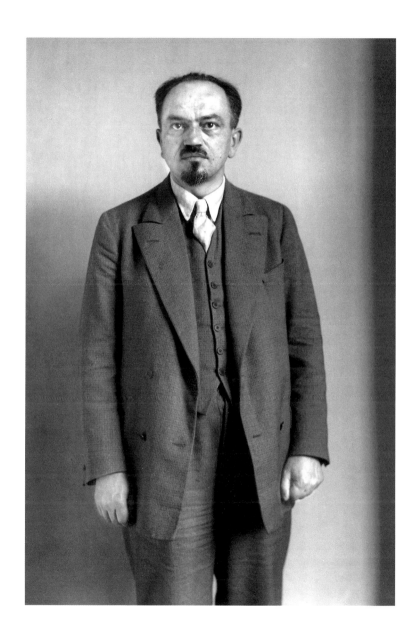

24 Communist leader

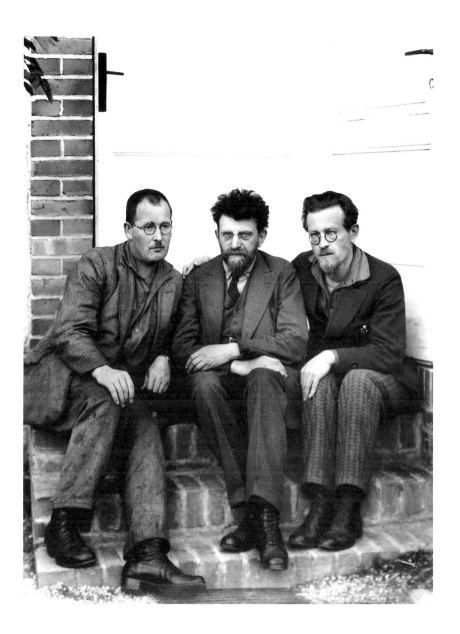

25 Revolutionaries

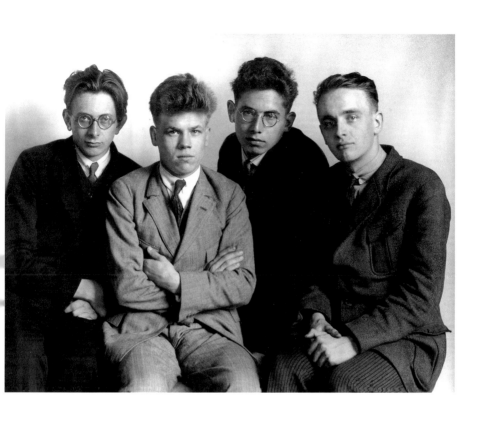

26 Working students

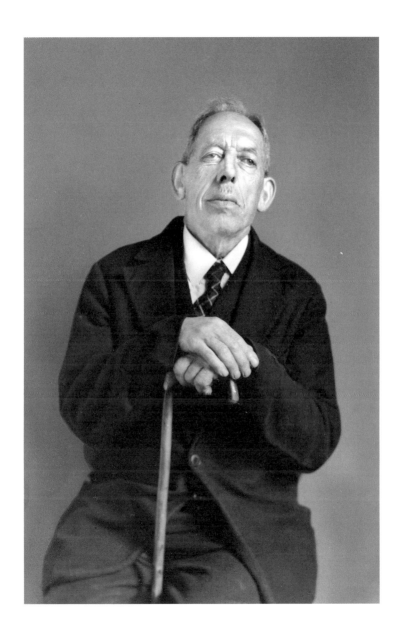

27 The herbal medicine expert

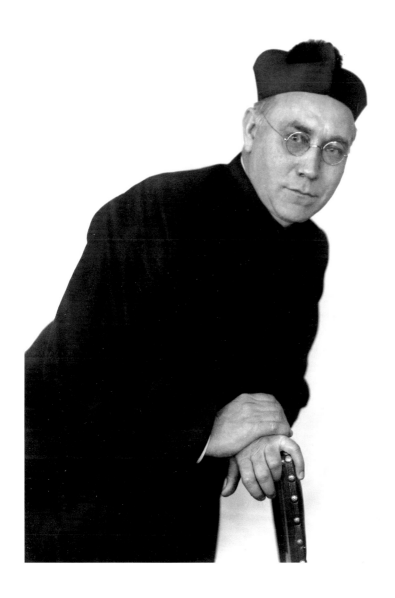

28 Catholic clergyman

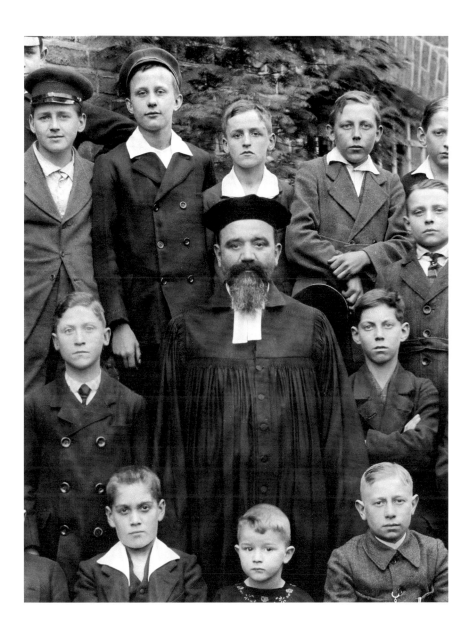

29 Protestant clergyman

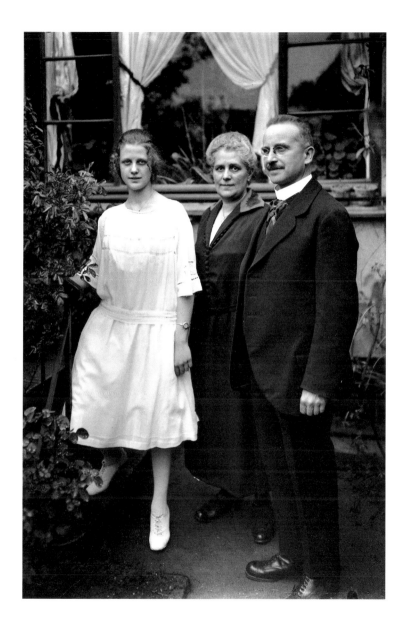

30 Middle-class family 1923

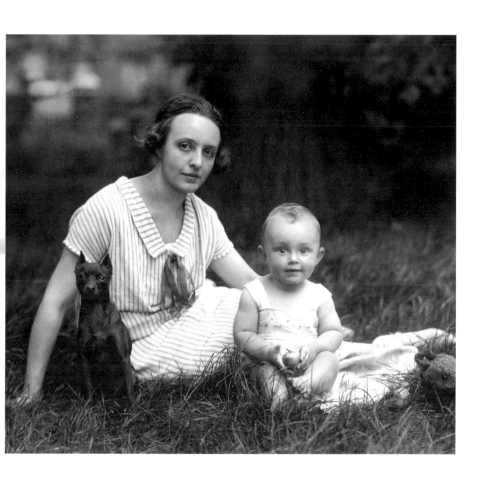

31 Young mother, middle-class

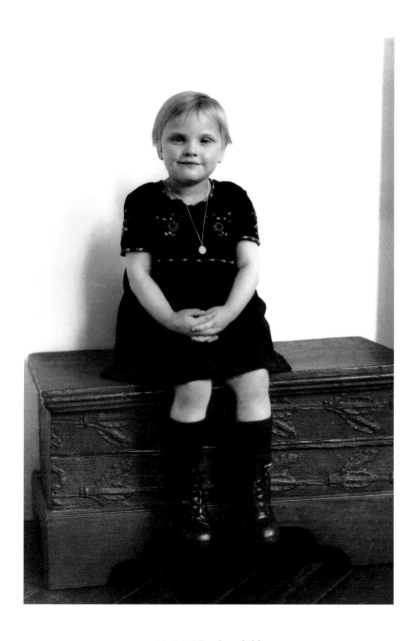

32 Middle-class child

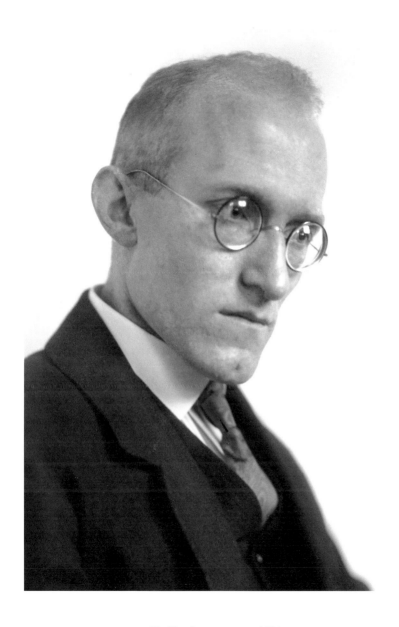

33 Youth movement 1923

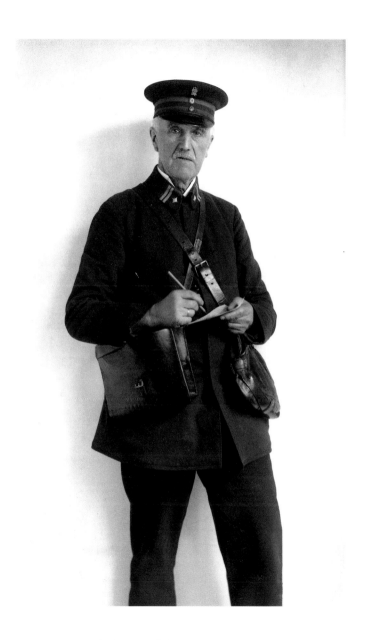

34 Postman delivering money orders

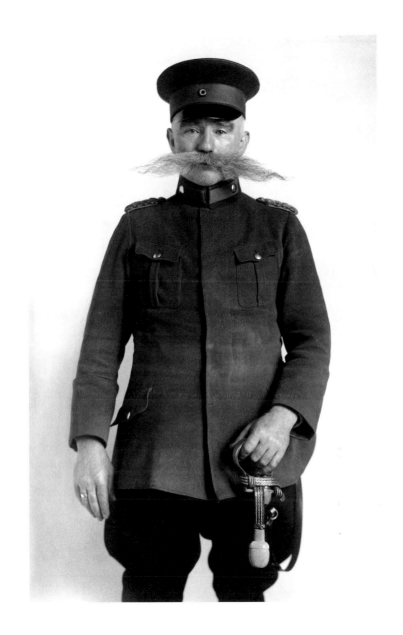

35 Police constable 1925

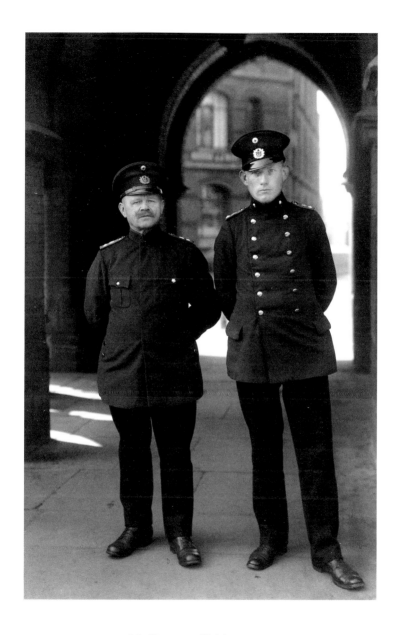

36 Customs officials 1929

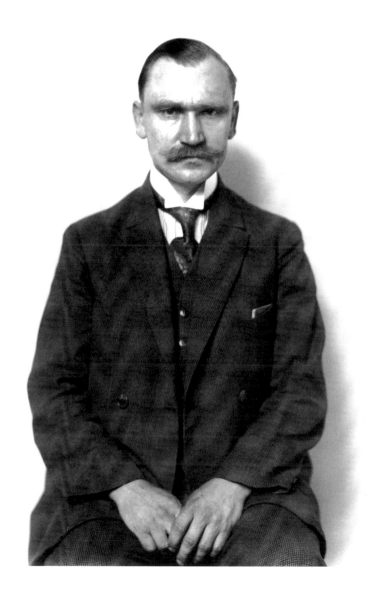

37 Production engineer

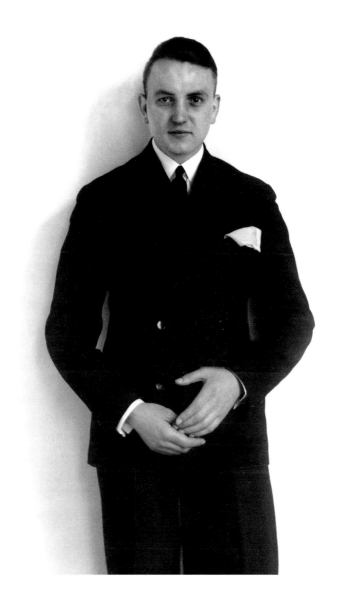

38 The young businessman

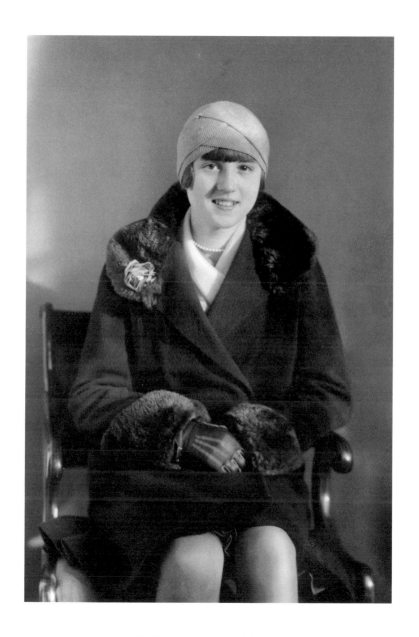

39 Grammar-school girl 1928

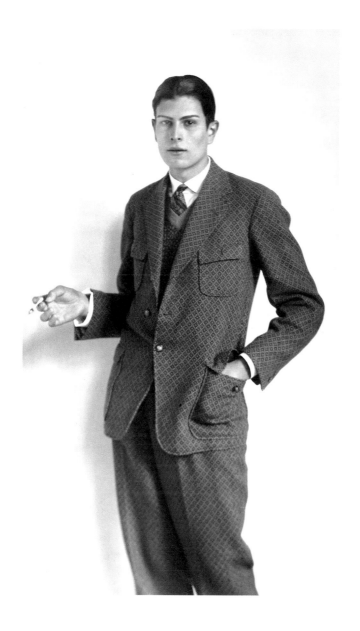

40 Grammar-school boy 1926

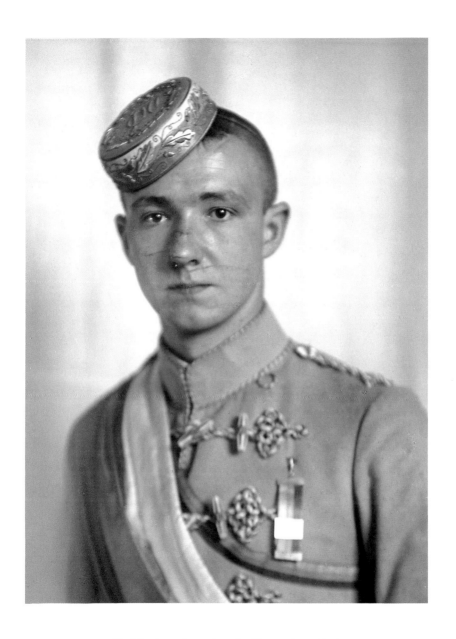

41 Member of a student duelling society 1925

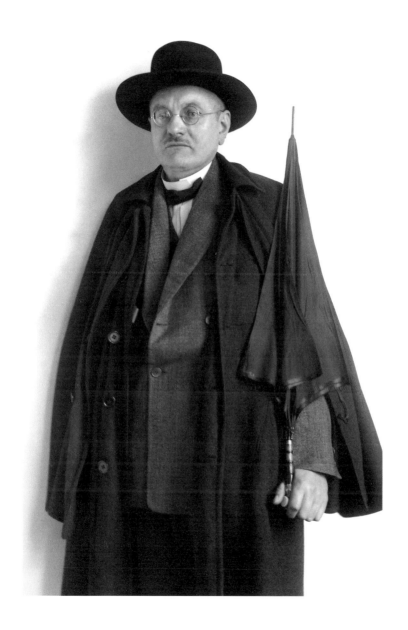

42 Member of parliament (democrat)

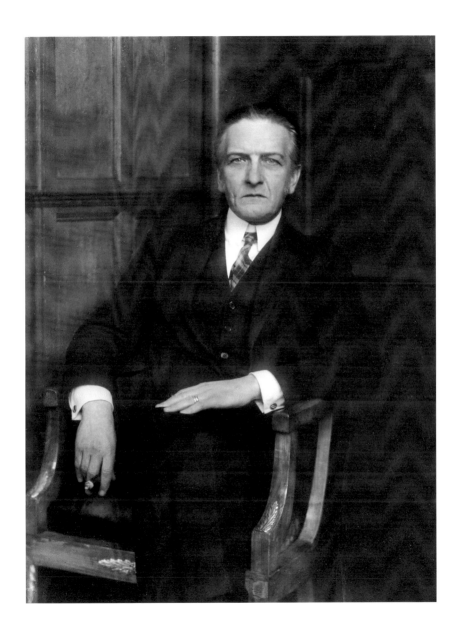

43 The art scholar

44 The doctor. Prof. S., Berlin

45 The industrialist

46 Tycoon. *Kommerzienrat* A. von G., Cologne

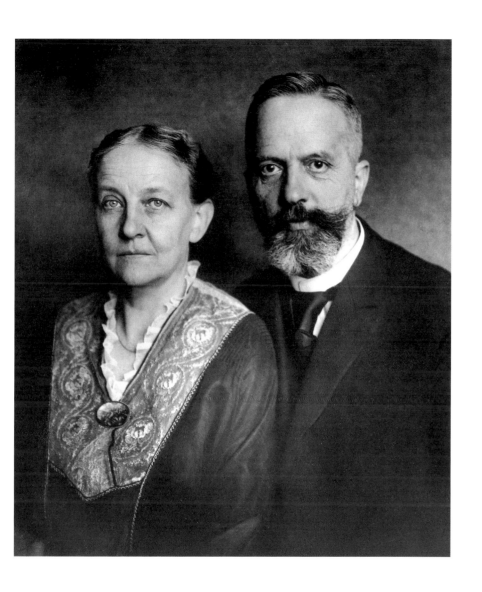

47 Wholesale merchant and wife

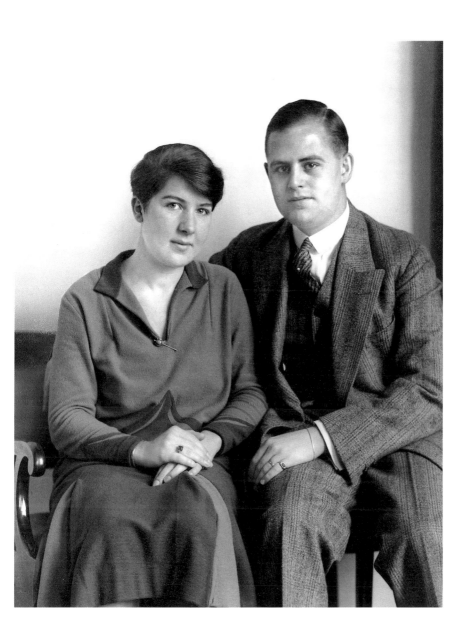

48 Middle-class professional couple

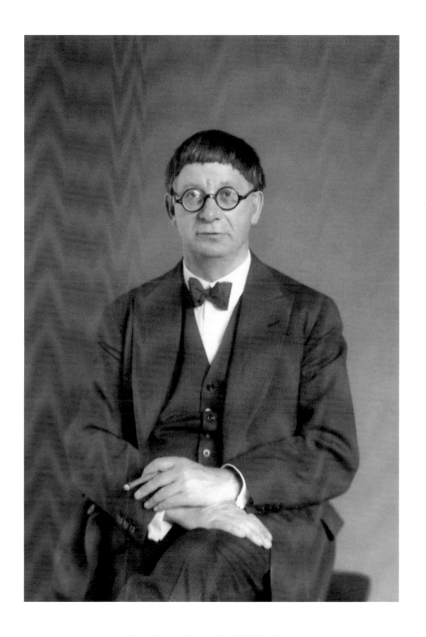

49 The architect. Prof. P., Berlin

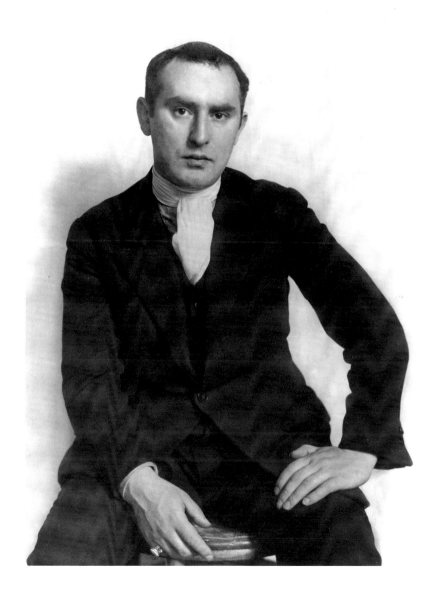

50 The painter 1924

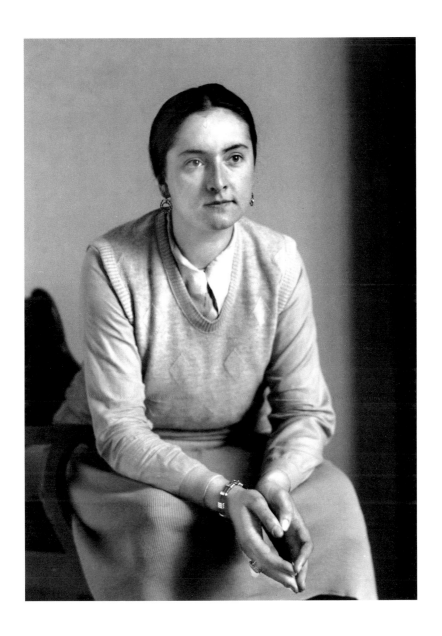

51 Sculptress 1929

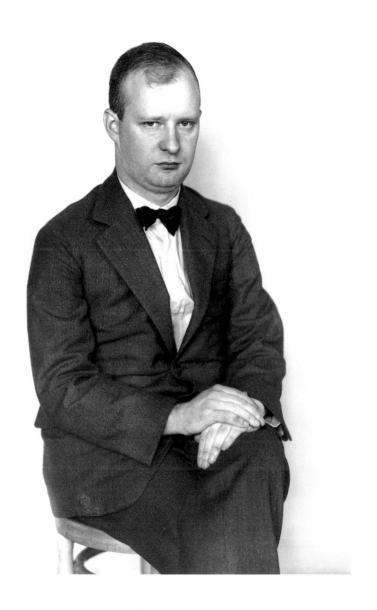

52 The composer P. H.

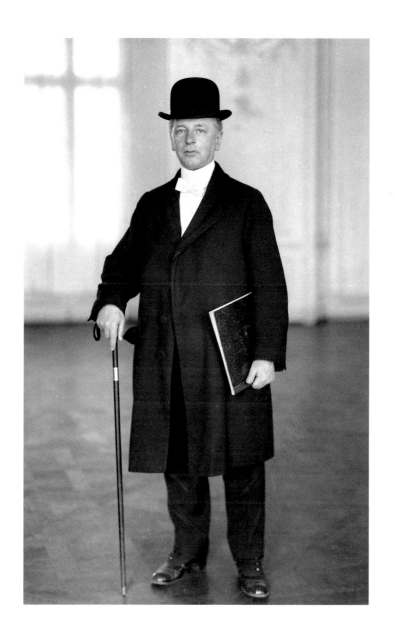

53 The pianist

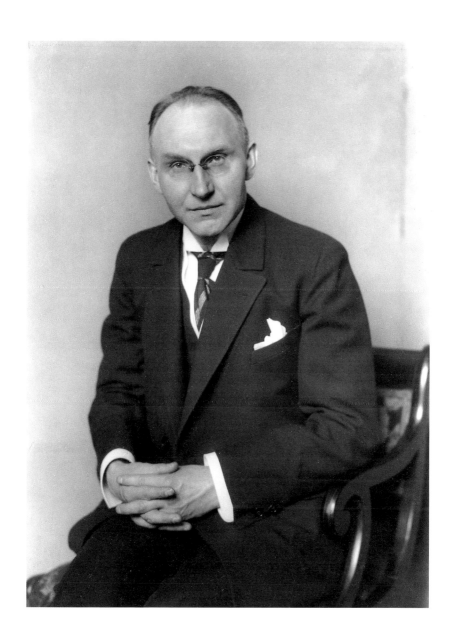

54 Writer and literary critic D.H.S.

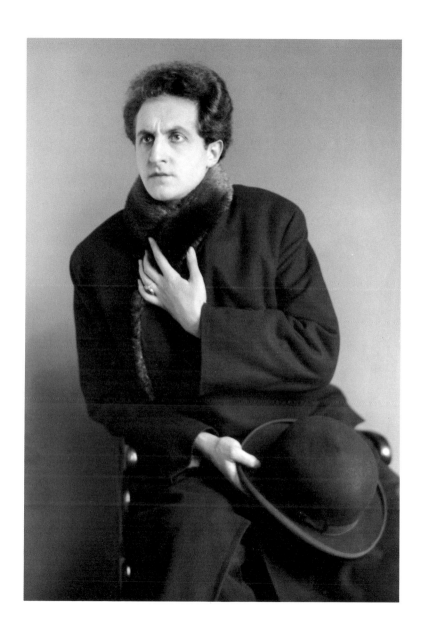

55 The tenor L. A.

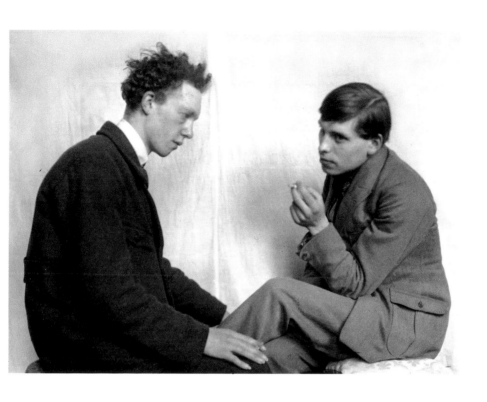

56 Bohemia

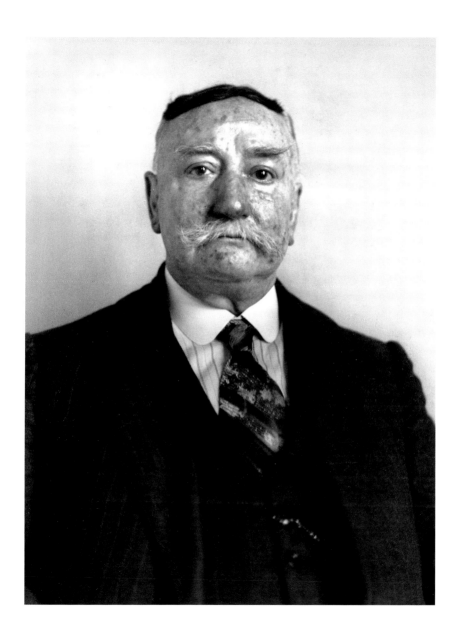

57 Barman

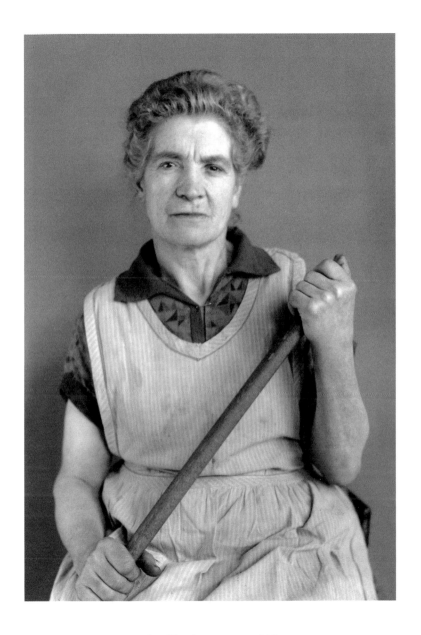

58 Cleaning woman 1928

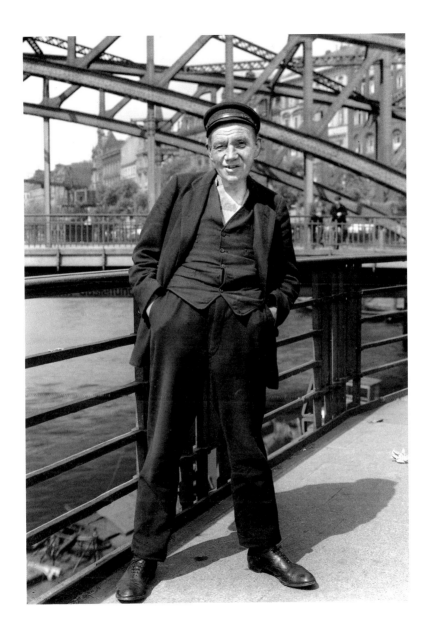

59 Redundant seaman

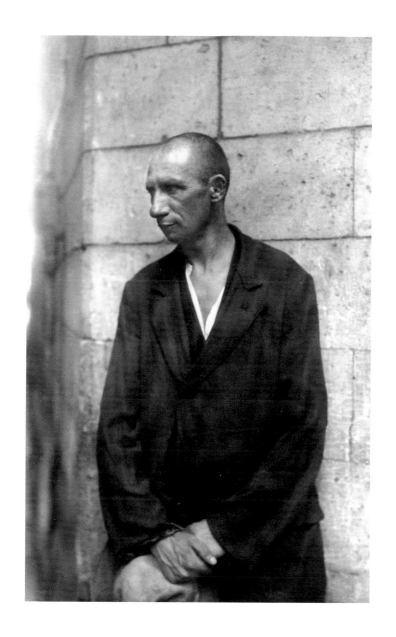

60 Unemployed 1928

Augmented List of Plates

The captions to the plates above correspond to the wording of the first edition of *Face of Our Time,* published in 1929.

For reasons of historical interest, we include here an augmented list of plates that complements the details given by August Sander with information drawn from more recent research: the names of identifiable figures in the portraits, and, when known, the place and date of the photographs. In addition, some of the dates have been revised on the basis of archive material.

1 Farmer, Westerwald, 1913
2 Shepherd, 1913
3 Westerwald farming woman, 1912/13
4 Farming couple, Westerwald, 1912
5 Three generations of a farming family, 1912
6 Young farmers, Westerwald, ca. 1914
7 Country girls, ca. 1928
8 Country bride and groom, ca. 1914
9 Prizewinners from a country choral society, ca. 1927
10 The landowner, ca. 1928
11 The teacher, 1913
12 Small-town citizens, Monschau, 1925/26
13 Boxers. Paul Röderstein and Hein Heese. Cologne, ca. 1928
14 Locksmith, Lindenthal, Cologne, ca. 1924
15 Interior decorator, Berlin, 1928
16 Pastrycook, Lindenthal, Cologne, ca. 1928
17 Mother and daughter, wives of a farmer and a miner, 1912
18 Proletarian children in the country, 1911/12
19 Worker's family, Leuscheid, ca. 1905
20 Proletarian mother, ca. 1928
21 Coalman, Berlin, 1929
22 Workers' council in the Ruhr, 1928/29
23 Odd-job man, Cologne, ca. 1928
24 Workers' leader. Paul Fröhlich, official of the Sozialistische Arbeiterpartei (SAP). Frankfurt, 1928/29
25 Revolutionaries. Centre: Erich Mühsam. Berlin, 1928
26 Working students. Left: August Sander's son Erich. Cologne, ca. 1926
27 The herbal medicine expert, Cologne, ca. 1928
28 Catholic clergyman, Cologne, 1925/26
29 Protestant clergyman with candidates for confirmation, Cologne, 1925

Biographical Sketch

1876 Born on 17 November in Herdorf, Siegerland, Germany. Sander's father, a carpenter in the mining industry, owns a farm. August Sander starts taking photographs even while still young.

1896 Military service in Trier. Begins an apprenticeship in photography at the Atelier Jung in Trier.

1899 'Travelling years', in which he visits Magdeburg, Halle, Leipzig, and Berlin to gain further experience at various photographic firms. Briefly attends the Academy of Painting in Dresden.

1901 1 January: begins job as '1st Operator' at the Atelier Greif in Linz, Austria. He soon becomes the owner of the business. Marriage to the daughter of a legal official in Trier. Becomes a flourishing small-town businessman: the studio now has seven employees, with his wife working in it as well.

1909 Towards the end of the year he moves to the Lindenthal district of Cologne and opens a new studio. Extensive photographic activity in the Westerwald and Siegerland regions.

1914 The First World War causes an almost total break in Sander's photographic activities. After the war, he joins the artists' association known as the 'Rhineland Progressives' (including Franz W. Seiwert and Heinrich Hoerle).

1924 August Sander makes his first uncommissioned 'portraits of professions' — earlier Westerwald experiments are an exception.

1927 Exhibition at the Kunstverein in Cologne: portraits and photographs 'of good and bad buildings'. Loss of lucrative commissions from the owners of the buildings Sander classifies as 'bad'.

1929 First edition of sixty portrait photographs, published by the Kurt Wolff Verlag: *Anlitz der Zeit* (Face of Our Time), with a foreword by Alfred Döblin.

1931 Invited by a Cologne radio station to give a series of lectures on 'The Essence and Development of Photography'.

1933 Sander is not invited to participate in the Nazi-influenced photographic exhibition 'The Camera' in Berlin.

1934 The *Reichskammer für bildende Künste* (Reich Chamber for the Fine Arts) orders the destruction of the printing plates of *Antlitz der Zeit* and confiscation of the remaining stock of the book.
 During the following years, Sanders secretly produces several portrait series, of persecuted Jews and 'politicians imprisoned under the Nazis'. More officially sanctioned include a systematic documentation of historic Cologne, 'Cöln, wie es war', and landscape shots in the Siebengebirge, Westerwald, and Eifel regions and on the Moselle and Rhine. The Rhine series was published posthumously as *Rheinlandschaften* (Munich, 1975).

1943 During the summer, August Sander puts his most artistically valuable photographic material into a truck and transports it to Kuchhausen, a village near Bad Honnef.

1944 Sander's studio in Lindenthal, Cologne, is destroyed during bombing. Moves to Kuchhausen.

1951 Special exhibition of August Sander's photographic work at the Photokina fair in Cologne.

1958 Sander is given the freedom of the city of Herdorf, and is made an honorary member of the 'Deutsche Photographische Gesellschaft' (German Photographic Society).

1960 Exhibition in Berlin. Award of the Order of the Federal Republic of Germany, 1st Class (equivalent to the British OBE).

1961 August Sander receives one quarter of the German Photographic Society's cultural prize.

1962 *Deutschenspiegel* (Mirror of the Germans), a selection of portraits, is published in book form.

1964 August Sander dies on 20 April after a stroke.

Bibliography

Sander, August. *Antlitz der Zeit. Menschen des 20. Jahrhunderts.* Introduced by Alfred Döblin. First edition, Munich: Wolff, 1929.

——. Series: 'Deutsche Lande – Deutsche Menschen':
Bergisches Land. Düsseldorf, 1933.
Die Eifel. Düsseldorf, 1933.
Die Mosel. Rothenfelde, 1934.
Das Siebengebirge. Rothenfelde, 1934.
Die Saar. Rothenfelde, 1934.

——. *Deutschenspiegel. Menschen des 20. Jahrhunderts.* Introduced by H. Lützeler. Gütersloh, 1962.

——. *Rheinlandschaften. Photographien 1929–1946.* With a note by Wolfgang Kemp. Munich, 1975.

——. *Menschen ohne Maske. Photographien 1906–1952.* With a biographical note by Gunther Sander. Munich, 1976.

——. *Mensch und Landschaft.* With a note by V. Kahmen [exhibition catalogue]. Rolandseck, 1977.

——. *Menschen des 20. Jahrhunderts. Portraitphotographien 1892–1952,* ed. Gunther Sander. With a note by Ulrich Keller. Munich, 1980.

Gasser, M. 'Auskunft über den Fotografen August Sander,' in H. Loetscher, ed., *Welt vor Augen: Reisen und Menschen.* Zurich, 1964.

Misselbeck, Reinhold, ed. *August Sander. Köln-Portrait.* Cologne, 1984.

Philipp, Claudia Gabriele. *August Sanders Projekt 'Menschen des 20. Jahrhunderts'. Rezeption und Interpretation* [dissertation]. Marburg, 1988.

Ranke, Winfried, ed. *August Sander. Die Zerstörung Kölns.* With texts by Heinrich Böll and W. Ranke. Munich, 1985.

Sachsse, Rolf. *August Sander. Die Köln-Mappen. Köln wie es war* [exhibition catalogue]. Cologne, 1988.

——. *August Sander in Viersen.* Viersen, 1989.